Nymphs

THE ITALIAN LIST

Nymphs

GIORGIO AGAMBEN

TRANSLATED BY AMANDA MINERVINI

Series Editor: *Alberto Toscano*

LONDON NEW YORK CALCUTTA

Seagull Books, 2013

Ninfe © Giorgio Agamben, 2007. Originally published by Bollati
Boringhieri editore, Torino. Published in arrangement with Agnese
Incisa Agenzia Letteraria.

English translation © The Board of Trustees of the Leland Stanford
Jr. University, 2011.

'Nymphs' was first published by Stanford University Press in Jacques
Khalip and Robert Mitchell (eds), *Releasing the Image: From Kant to New
Media* (2011).

ISBN 978 0 8574 2 094 7

British Library Cataloguing-in-Publication Data
A catalogue record for this book is available
from the British Library

Typeset by Seagull Books, Calcutta, India
Printed and bound by Hyam Enterprises, Calcutta, India

It is quite true they are all females, but they don't piss.

Boccaccio

1

In the first months of 2003, the J. Paul Getty
Museum in Los Angeles showed a video exhibit by
Bill Viola entitled *Passions*. During a stay at the Getty
Research Institute, Viola had worked on the expres-
sion of passions, a theme codified by Charles Le Brun
in the seventeenth century and taken up again in the
nineteenth century by Duchenne de Boulogne and
Charles Darwin on a scientific and experimental
basis. The videos presented at the exhibition were the
results of this period of research. At first sight, the
images on the screen appeared to be still but, after a
few seconds, they started to become animate, almost
imperceptibly. The spectator then realized that the

images had always been in movement and that it was only the extreme slowdown that, by dilating the temporal moment, had made them appear immobile. This effect explains the impression of simultaneous familiarity and strangeness [*estraneazione*] that the images stirred up. It was as if one entered the room of a museum and the old masters' canvases miraculously began to move.

At this point, the spectator familiar with art history would have recognized in the three extenu-ated figures of *Emergence, Pietà* by Masolino da Pan-icale; in the astounded quintet of *Astonished, Christ Mocked (The Crowning with Thorns)* by Hieronymous Bosch; and in the weeping couple of the *Dolorosa*, the diptych attributed to Dieric Bouts in London's National Gallery. However, what was decisive in each case was less the transposition of the figure into a modern setting as the setting into motion of the iconographic theme. Under the incredulous eyes of

the spectator, the *musée imaginaire* becomes the *musée cinématographique*.

Because the event that they present can last up to twenty minutes, these videos require a type of attention to which we are no longer accustomed. If, as Walter Benjamin has shown, the reproduction of the work of art is content with a distracted viewer, Viola's videos instead force the spectator to wait— and to pay attention—for an unusually long time. The spectator who arrived at the end—as one used to do at the cinema as a child—would feel obliged to re-watch the video from the beginning. In this way, the immobile iconographic theme is turned into history. This appears in an exemplary fashion in *The Greeting*, a video exhibited at the Venice Biennale in 1995. Here, the spectator could see the female figures that appear entwined in Pontormo's *Visitazione* as slowly moving towards each other and ultimately recomposing the iconographic theme of the canvas of Carmignano.

At this point, the spectator realizes with surprise that what caught his attention is not only the animation of images that he was used to considering immobile but, rather, a transformation that concerns the very nature of those images. When, in the end, the iconographic theme has been recomposed and the images seem to come to rest, they have actually charged themselves with time, almost to the point of exploding. Precisely this kairological saturation imbues them with a sort of tremor that in turn constitutes their particular aura. Every instant, every image virtually anticipates its future development and remembers its former gestures. If one had to define the specific achievement of Viola's videos with a formula, one could say that they insert not the images in time but time in the images. And because the real paradigm of life in the modern era is not movement but time, this means that there is a life of images that is our task

to understand. As the author himself states in an interview published in the catalogue, 'the essence of the visual medium is time . . . images live within us. At this moment we each have an extensive visual world inside of us . . . We are living databases of images—collectors of images—and these images do not stop transforming and growing once they get inside us.'[1]

2

How can an image charge itself with time? How are
time and images related? Around the middle of the
fifteenth century, Domenico da Piacenza composed
his essay 'Dela arte di ballare et danzare' (On the
Art of Dancing and Choreography). Domenico—
or rather Domenichino, as his friends and disciples
called him—was the most famous choreographer of
his time, a master of dance at the Sforza court in
Milan and at the Gonzaga court in Ferrara. Although
at the beginning of his essay, quoting Aristotle, he
insists on the dignity of dance, which requires 'as
much intellect and effort one can find',[2] Domenico's
treatise is situated on a middle ground between a

didactic handbook and an esoteric compendium
derived from the oral tradition passed down from
teacher to student. Domenico lists six fundamental
elements of the art: measure, memory, agility, man-
ner, measure of the ground and 'phantasmata'. This
last element—in truth, the absolutely central one—
is defined as follows:

> I say that whoever wants to learn this art,
> needs to dance through phantasmata; note
> that phantasmata are a kind of corporeal
> swiftness that is controlled by the under-
> standing of the measure This necessi-
> tates that at each *tempo* you appear as if you
> had seen Medusa's head, as the poet says;
> after having performed the movement, you
> should appear entirely made of stone in
> that instant and in the next you should put
> on wings like a falcon moved by hunger,
> according to the above rule, that is to say,

employing measure, memory, manner with measure of ground and air. [3]

Domenico calls 'phantasm' (*fantasma*) a sudden arrest between two movements that virtually contracts within its internal tension the measure and the memory of the entire choreographic series.

Dance historians have wondered about the origin of this 'dancing through phantasmata', 'a simile with which,' according to his disciples, the teacher meant to convey 'many things that one cannot tell'. It seems certain that this doctrine derives from the Aristotelian theory of memory, condensed in the brief essay 'On Memory and Recollection', which had a determinant influence on mediaeval and Renaissance psychology. Here, the philosopher, by tightly binding time, memory and imagination, affirmed that only the beings that perceive time can remember, and they do so with the same faculty with which they perceive time that is, with imagination.

Indeed, memory is impossible without an image (phantasm), which is an affect, a *pathos* of sensation or of thought. In this sense, the mnemic image is always charged with an energy capable of moving and disturbing the body:

> That this condition affects the body, and that recollection is the search for an image in a corporeal organ, is proved by the fact that many persons are made very restless when they cannot recall a thing, and when quite inhibiting their thought, and no longer trying to remember, they do recollect nevertheless, as is especially true of the melancholic. For such persons are most moved by images. The reason why recollection does not lie within our power is this: just as a person who has thrown an object can no longer bring it to rest, so too one who recollects and goes in search of a

thing, sets a corporeal something in motion,

in which the desired experience resides.[4]

Therefore, for Domenico, dancing is essentially an operation conducted on memory, a composition of phantasms within a temporally and spatially ordered series. The true locus of the dancer is not the body and its movement but the image as a 'Medusa's head', as a pause that is not immobile but simultaneously charged with memory and dynamic energy. This means, however, that the essence of dance is no longer movement but time.

3

It is not improbable that Aby Warburg knew the
treatise by Domenico (and his pupil, Cornazano)
when he prepared his 'Theatrical Costumes for the
Intermedi of 1589' during his sojourn in Florence.
Certainly, nothing resembles his vision of the image
as *Pathosformel* more than the 'phantasmata' that
contracts within itself in an abrupt stop the energy
of movement and memory. The resemblance also
extends to the spectral, stereotypical fixity that seems
to accord as much with Domenico's 'phantasmatic
shadow' (in the words of Cornazano, who misun-
derstands his teacher) as with Warburg's *Pathosformel*.
The concept of the *Pathosformel* appears for the first

time in the 1905 essay on Albrecht Dürer and Italian antiquity, which traces back the iconographic theme of one of Dürer's etchings to the 'pathetic gestural language' of ancient art. Warburg gives evidence for such a connection by retracing a *Pathosformel* in a Greek vase painting, in an etching by Andrea Mantegna and in the xylographs of a Venetian incunabulum. First of all, it is important to pay attention to the term itself: Warburg does not write, as he could have, *Pathosform*, but *Pathosformel*—pathos formula—thus emphasizing the stereotypical and repetitive aspect of the imaginal theme with which the artist had to grapple in order to give expression to 'life in movement' (*bewegtes Leben*). Perhaps the best way to understand its meaning is to compare it with the usage of the word 'formula' in Milman Parry's studies on Homer's formulaic style, published in Paris during the same years that Warburg was at work on his *Mnemosyne Atlas*. The young American philologist

had renewed the field of Homeric philology by showing how the oral composition technique of the Iliad and the Odyssey was based on a vast but finite repertoire of verbal combinations (the famous Homeric epithets: the swift-footed Achilles, Hector's flashing helmet, Odysseus of many turns, etc.). These formulae are rhythmically configured so that they can be adapted to portions of the verse; they are themselves composed of interchangeable metrical elements that allowed the poet to vary syntax without changing metrical structure. Albert Lord and Gregory Nagy have shown that formulae are not just semantic fillers destined to occupy a metrical slot, but that, to the contrary, the metre probably derives from the formula traditionally passed down. Along the same lines, the formulaic composition entails the impossibility of distinguishing between creation and performance, between original and repetition. In Lord's words, 'an oral poem is not composed

for but in performance'.[5] This means that formulae, exactly like Warburg's *Pathosformeln*, are hybrids of matter and form, of creation and performance, of first-timeness [*primavoltità*] and repetition.

Let us consider the *Pathosformel* '*Ninfa*' to which the forty-sixth plate of the *Atlas* is devoted. The plate contains twenty-six photographs, starting from a seventh-century Longobard relief to a fresco by Domenico Ghirlandaio in Santa Maria Novella (this latter portrays the female figure that Warburg jokingly called 'Miss Quickbring' and that, in an exchange about the nymph, André Jolles character-izes as 'the object of my dreams that turns each time into an enchanting nightmare'[6]). The same table also contains figures from Raphael's water carrier to a Tuscan peasant woman photographed by War-burg in Settignano. Where is the nymph? In which one of the table's twenty-six apparitions does it reside? To search among them for an archetype or

an original from which the others have derived
would amount to misreading the *Atlas*. None of the
images is the original; none is simply a copy. In the
same sense, the nymph is neither passional matter
to which the artist must give a new form, nor a
mould into which he must press his emotional mate-
rials. The nymph is an indiscernible blend of origi-
nariness and repetition, of form and matter. But a
being whose form punctually coincides with its mat-
ter and whose origin is indissoluble from its becom-
ing is what we call time, and which Immanuel Kant,
on the same basis, defined in terms of self-affection.
Pathosformeln are made of time—they are crystals of
historical memory, crystals which are 'phantasma-
tized' (in Domenico's sense) and round which time
writes its choreography.

4

In November 1972, Nathan Lerner, a Chicago photographer and designer, opened the door of the room at 851 Webster Avenue in which his tenant, Henry Darger, had lived for forty years. Darger, who had left the room a few days earlier to move to an assisted-living home, was a quiet but certainly bizarre man. He had supported himself until that moment by washing dishes in a hospital; he was always on the verge of poverty; his neighbours sometimes heard him talking to himself in the voice of a little girl. He rarely went out; and when he did, he was spotted rummaging in the garbage like a tramp. In the summer, when the temperature in Chicago all of a sudden turns sultry he used to sit

on the outside steps, staring into the void (this is how his only recent picture portrays him). But when, in the company of a young student, Lerner entered the room, he found an unexpected scene before him. It had not been easy to find his way through the piles of all kinds of objects (balls of string, empty bismuth bottles, newspaper clippings); but heaped up in a corner on an old chest were about fifteen hand-bound typed volumes that contained a sort of romance, almost thirty-thousand pages long, eloquently entitled *In the Realms of the Unreal.*[7] As the front cover explained, it tells the story of seven little girls (the Vivian girls) who lead a revolt against cruel adults (the Glandolinians) who enslave, torture, strangle and eviscerate them. It was even more surprising to discover that the solitary tenant was also a painter who for forty years had patiently illustrated his novel across dozens and dozens of watercolour canvas and paper panels, at times almost ten-feet tall. In them the naked girls, who usually have a little male

organ, wander in self-absorption or play in idyllic landscapes among flowers and marvellous winged creatures (the Blengiglomean serpents); these images alternate with sadistic scenes of inconceivable violence in which the bodies of the little girls are tied, beaten, strangled and, in the end, opened in order to carve out the bloody viscera.

What interests us the most is Darger's ingenious compositional procedure—he would cut images of little girls from comics or newspapers and copy them on tracing paper; if an image was too small, he would photograph it and have it magnified to suit his purpose. In this way, the artist ultimately had at his disposal a formulaic and gestural repertoire (serial variations of one *Pathosformel* that we can call *nympha dargeriana*) that he could freely combine in his large panels by means of collage or tracing. Darger thus offers the extreme case of an artistic composition solely made of *Pathosformeln*, one that produces an extraordinary effect of modernity.

But the analogy with Warburg is even more essential. The critics who have commented on Darger have underlined the pathological aspects of a personality that presumably had never overcome infantile traumas and that undoubtedly exhibited autistic traits. However, it is much more interesting to enquire into Darger's relationship to his *Pathosformeln*. Certainly, he lived for forty years totally immersed in his imaginary world. Like every true artist, he did not want to construct the image of a body but a body for the image. His work, like his life, is a battlefield whose objective is the *Pathosformel*— 'the Dargerian nymph', the nymph enslaved by evil adults (often represented as professors with caps and gowns). The images that constitute our memory tend incessantly to rigidify into spectres in the course of their (collective and individual) historical transmission. Hence, the task is to bring them back to life. Images are alive, but, because they are made of time and memory, their life is always-already *Nachleben*

(posthumous life or afterlife); it is always-already threatened and in the process of taking on a spectral form. To free images from their spectral destiny is the task that both Darger and Warburg, at the threshold of an essential psychic danger, entrust to their work—one to his endless novel, the other to his nameless science.

5

Warburg's research is contemporaneous with the
birth of cinema. At first sight, what the two phenom-
ena seem to have in common is the problem of the
representation of movement. But Warburg's interest
in the representation of the body in movement—the
bewegte Leben that finds its canonical example in the
nymph—was not so much motivated by technico-
scientific or aesthetic reasons as by his obsession with
what one could call 'the life of images'. This theme
(whose relations to cinema are yet to be investigated)
delineates a current that is not of secondary impor-
tance in the thought and the poetics (and perhaps
in the politics) of the beginning of the twentieth

century—from Ludwig Klages to Walter Benjamin, from Futurism to Henri Focillon. From this perspective, the proximity of Warburg's research to the birth of cinema acquires a new significance. In both cases, the effort is to catch a kinetic potentiality that is already present in the image—whether as an isolated film still or a mnestic *Pathosformel*—and that concerns what Warburg defined with the term *Nachleben.*

It is well known that the origin of the precursors to cinema (Joseph Plateau's phenakistoscope, Simon von Stampfer's zoetrope or John Ayrton Paris' thaumatrope) was the discovery of the persistence of the retinal image. As we read in the explanatory brochure of the thaumatrope, it has been now experimentally proven that the image received by the mind in this way persists for about one eighth of a second after the image has been removed . . . the thaumatrope is based on this optical principle: the impression left on

the retina by the image drawn on paper is not erased before the image painted on the other side has reached the eye. The consequence is that you will see the two images at the same time. The viewer looking upon a disc of moving paper with a bird drawn on one side and a cage on the other would see the bird entering the cage because of the fusion of the two retinal images separated in time.

It can be affirmed that Warburg's discovery consists of the fact that, alongside the physiological *Nachleben* (the persistence of retinal images), there exists a historical *Nachleben* of images based on the persistence of a mnestic charge that constitutes them as 'dynamograms'. Warburg is the first one to have noticed that the images passed down by historical memory (Klages and Jung are interested instead in meta-historical archetypes) are not inert and inanimate but possess a special and diminished life that he calls, indeed, posthumous life or afterlife. And just as

the phenakistoscope—and just as later, in a different way, cinema—must succeed in catching the retinal afterlife in order to set the images in motion, so too the historian must be able to grasp the posthumous life of *Pathosformeln* in order to restore to them the energy and temporality they once contained. The afterlife of images is not, in fact, a given but requires an operation and this is the task of the historical subject (just as it can be said that the discovery of the persistence of retinal images calls for cinema, which is able to transform it into movement). By way of this operation, the past—the images passed down from preceding generations—that seemed closed up and inaccessible is reset in motion for us and becomes possible again.

6

Beginning from the mid-1930s, while at work on his Paris book and then on his study of Baudelaire, Benjamin elaborates the concept of dialectical image (*dialektisches Bild*) that was to provide the pivot for his theory of historical knowledge. Perhaps in no other text is Benjamin so close to giving a definition of the concept as he does in a fragment of the *Arcades Project* (N3,1). Here he distinguishes the dialectical image from the 'essences' of Husserl's phenomenology. While the latter are known independently from every factual given, dialectical images are defined by their historical index that refers them to the present. And while for Husserl intentionality

remains the presupposition for phenomenology, in the dialectical image truth appears historically as 'death of the *intentio*'. This means that Benjamin assigns to dialectical images a dignity comparable to that of the *eidei* in phenomenology and to that of ideas in Plato. Philosophy deals with the recognition and construction of such images. Benjamin's theory contemplates neither essences nor objects but images. However, for Benjamin, it is decisive that images be defined through a dialectical movement caught in the moment of its standstill (*Stillstand*): 'It is not that what is past casts its light on what is present, or what is present its light on what is past; rather, image is that wherein what has been comes together in a flash with the now (*jetzt*) to form a constellation. In other words, image is dialectics at a standstill' (*Stillstand* does not indicate simply arrest but a threshold between immobility and movement).[8] In another fragment, Benjamin quotes

a passage by Focillon in which classical style is defined as:

> A brief, perfectly balanced instant of complete possession of forms . . . a pure, quick delight, like the akmé of the Greeks, so delicate that the pointer of the scale scarcely trembles. I look at this scale not to see whether the pointer will presently dip down again, or even come to a moment of absolute rest. I look at it instead to see, within the miracle of that hesitant immobility, the slight, inappreciable tremor that indicates life.[9]

Just as in Domenico's 'dancing through phantasmata', the life of images consists neither of simple immobility nor of the subsequent return to motion but of a pause highly charged with tension between the two. 'Thinking involves not the flow of thoughts, but their arrest as well.

Where thinking suddenly stops in a configuration pregnant with tensions,' we read in the seventeenth thesis on the philosophy of history, 'it gives that configuration a shock, by which it crystallizes into a monad'.[10]

The exchange of letters with Adorno in the summer of 1935 clarifies the sense in which the extremes of this polar tension are to be understood. Adorno defines the concept of dialectical image starting from Benjamin's notion of allegory in the *Trauerspielbuch*, which speaks of a 'hollowing out of meaning' carried out in objects by the allegorical intention.

> With the vitiation of their use value, the alienated things are hollowed out and, as ciphers, they draw in meanings. Subjectivity takes possession of them insofar as it invests them with intentions of desire and fear. And insofar as defunct things stand in as images

of subjective intentions, these latter present themselves as immemorial and eternal. Dialectical images are constellated between alienated things and incoming and disappearing meaning—are instantiated in the moment of indifference between death and meaning.[11]

Copying this passage onto his notecards, Benjamin comments 'with regard to these reflections, it should be kept in mind that, in the nineteenth century, the number of "hollowed-out" things increases at a rate and on a scale that was previously unknown, for technical progress is continually withdrawing newly introduced objects from circulation'.[12] Where meaning is suspended, dialectical images appear. The dialectical image is, in other words, an unresolved oscillation between estrangement and a new event of meaning. Similar to the emblematic intention, the dialectical image holds its object suspended

in a semantic void. Hence its ambiguity, criticized by Adorno ('the ambiguity must absolutely not be left as it is'[13]). Adorno, who is ultimately attempting to bring the dialectic back to its Hegelian matrix, does not seem to understand that, for Benjamin, the crux is not a movement that by way of mediation leads to the *Aufhebung* of contradiction but the very moment of standstill—a stalling in which the middle point is exposed like a zone of indifference between the two opposite terms. As such it is necessarily ambiguous. The *'Dialektik im Stillstand'* of which Benjamin speaks implies a dialectic whose mechanism is not logical (as in Hegel) but analogical and paradigmatic (as in Plato). According to Enzo Melandri's acute intuition, its formula is 'neither A nor B' and the opposition it implies is not dichotomous and substantial but bipolar and tensive—the two terms are neither removed from nor recomposed in unity but kept in an immobile coexistence

charged with tensions.[14] This means, in truth, that
not only is dialectic not separable from the objects
it negates but also that the objects lose their identity
and transform into the two poles of a single dialec-
tical tension that reaches its highest manifestation
in the state of immobility, like dancing 'through
phantasmata'.

In the history of philosophy, this 'dialectics at a
standstill' has an illustrious archetype—the passage
in the *Posterior Analytics* in which Aristotle compares
the sudden arrest of thought that produces the uni-
versal to a fleeing army in which a single soldier
abruptly stops, followed by another and then another,
until the initial unity is reconstituted. In this instance,
the universal is reached in the particular not induc-
tively but analogically, by way of its arrest. The mul-
tiplicity of the soldiers (that is to say, of thoughts and
perceptions) in disorderly flight is suddenly perceived
as a unity in the same way that Benjamin described

the sudden arrest of thought in a constellation—in an image deriving from Stéphane Mallarmé's *Coup de dés* in which the written page is elevated to the power of the starry sky and, at the same time, to the graphic tension of the *réclame*. For Benjamin, this constellation is dialectical and intensive, that it to say, capable of placing an instant from the past in relation to the present.

In a 1937 etching, the great art historian Focillon, who had inherited a passion for prints from his father, seems to have wanted to freeze this suspended restlessness of thought in an image—an acrobat hanging from his trapeze, swinging back and forth over the illuminated arena of a circus. At the bottom right, he wrote its title: *La dialectique*.

7

The influence exercised on young Warburg by
Friedrich Theodor Vischer's essay on the symbol
['Das Symbol'] is well known. According to Vischer,
the proper space of the symbol is situated between
the obscurity of mythico-religious consciousness, that
more or less immediately identifies image (*Bild*) and
meaning (*Bedeutung, Inhalt*), and the clarity of reason,
which keeps them distinct at every point. 'We call
symbolic,' writes Vischer, 'a once believed mythical
element, not objectively believed, yet with the lively
backward transposition of a belief that is assumed
and taken up as freely aesthetic—not an empty but
rather a meaningful phantasmic image (*sinnvolles*

Scheinbild)'.[15] Thus, between mythico-religious and rational consciousness, one must introduce

> a second fundamental form that lies in the middle between free and unfree, light and dark, in order first to let the entirely free and light to result as a third element [. . .] The *middle (die Mitte)*: we can also designate what concerns us now as a peculiar *twilight (Zwielicht)*. It is the involuntary but free— unconscious and in a certain sense still conscious—natural animation *(Naturbeseelung)*, the granting act through which we subject our soul and its moods to the inanimate.[16]

Vischer calls this intermediate state in which the viewer no longer believes in the magico-religious power of images yet continues to be somehow connected to them, keeping them suspended between the efficacious icon and the purely conceptual sign *vorbehaltende* (suspending).

The influence that these ideas were to exercise on Warburg is evident. The encounter with images (*Pathosformeln*) happens in this neither conscious nor unconscious, neither free nor unfree, zone in which, nevertheless, human consciousness and freedom are at play. The human is thus decided in this no-man's-land between myth and reason, in the ambiguous twilight in which the living being accepts a confrontation with the inanimate images transmitted by historical memory in order to bring them back to life. Like Benjamin's dialectical images and Vischer's symbol, the *Pathosformeln*, which Warburg compares to dynamograms full of energy, are received in a state of 'unpolarized latent ambivalence' (*unpolarisierte latente Ambivalenz*); and only in this way—in the encounter with a living individual—can they obtain polarity and life.[17] The act of creation in which the individual—the artist or the poet, but also the scholar and even every human being—confronts images takes place in this central zone between two opposite poles of the

human (Vischer calls it 'the middle' and Warburg never tires of warning that 'the problem lies in the middle' [*das Problem liegt in der Mitte*][18]). We could define it as a zone of 'creative indifference', with reference to an image from Salomon Friedländer that Benjamin liked to quote.[19] The centre in question here is not geometrical but dialectical—it is not the middle point separating two segments on a line but the passage of a polar oscillation through it. Like Domenico's 'phantasmata', this centre is the immobile image of a being in transition [*di un essere di passaggio*]. This also means, however, that the operation Warburg entrusts to his *Atlas* is exactly the opposite of what is usually understood to belong under the rubric of 'historical memory'. According to Gianni Carchia's insightful formula, 'historical memory ends up revealing itself, in the space of memory, as an authentic collapse of meaning, the place of its very failure [*mancamento*]'.[20]

The *Atlas* is a sort of depolarization and repolarization station—Warburg speaks of 'disconnected dynamograms' (*abgeschnürte Dynamogramme*)[21]—in which the images from the past that lost their meaning and now survive as nightmares or spectres are kept suspended in the shadows where the historical subject, between waking and sleep, engages with them in order to bring them back to life but also, sooner or later, to awaken from them.

Among the sketches retrieved by Georges Didi-Huberman from the excavations of Warburg's manuscripts, besides various schemes of pendular oscillations, is a pen drawing of an acrobat walking on a plank held in precarious equilibrium by two other figures.[22] The acrobat, designated by the letter K—is perhaps the cipher of the artist (*Kunstler*) suspended between images and their content (elsewhere, Warburg talks about a 'pendular movement between the position of causes as images and as signs'[23]). The image may also be intended as the

cipher of the scholar who (as Warburg writes about Jacob Burkhardt) acts like 'a necromancer, who is fully conscious; thus he conjures up specters which quite seriously threaten him'.[24]

8

'Who is the nymph, where does she come from?'
Jolles asked Warburg in their exchange in Florence
in 1900 regarding the female figure in movement
painted by Ghirlandaio in the Tornabuoni chapel.[25]
Warburg's response sounds peremptory, at least
superficially: 'As a real being of flesh and blood she
may have been a freed slave from Tartary [. . .] but
in her true essence she is an elemental spirit (*Elemen-
targeist*), a pagan goddess in exile'.[26] The second part
of the definition (a pagan goddess in exile), upon
which scholarly attention has mostly lingered,
inscribes the nymph in the most proper context of
Warburg's research on the *Nachleben* of the pagan
gods. The connection between *Elementargeist* and

gods in exile is already in Heine, in his section on the *Elementargeister* that opens the essay 'Les dieux en exil'. It has not been noted, however, that the first part of the definition (the term *Elementargeist*) signals an esoteric branch in the genealogy of the nymph, a lineage that, although hidden, could not possibly be unknown to both Warburg and Jolles. For the term perspicuously refers to the Romantic tradition that, through Friedrich de la Motte Fouqué's *Undine*, stems from Paracelsus' essay 'De nymphis, sylphis, pygmeis et salamandris et caeteris spiritibus'.[27] In this derivation, at the crossroads among different cultural traditions, the nymph names the object par excellence of amorous passion (which she certainly was for Warburg: 'I should like to be joyfully whirled away with her,' he writes to Jolles.[28])

Let us now consider the essay written by Paracelsus and directly recalled by Warburg. Here, the nymph is inscribed in Paracelsus' doctrine of the

elemental spirits (or spiritual creatures), each of whom is connected to one of the four elements: the nymph (or undine) to water; sylphs to air; pygmies (or gnomes) to earth; and salamanders to fire. What defines those spirits, and the nymph in particular, is that, even if they resemble humans in every respect, they were not fathered by Adam; they belong to a second branch of creation: 'they are more like men than like beasts, but are neither'.[29] There exists, according to Paracelsus, a 'two-fold flesh': one coarse and earthly, springing from Adam; the other subtle and spiritual, from a non-Adamic ancestry.[30] (This doctrine, implying a special creation for some creatures, seems the exact counterpart of Isaac La Peyrère's proposal concerning the pre-Adamic creation of heathens.) What defines the elementals, in every case, is the fact that they do not have a soul and hence are neither men nor animals (since they possess reason and language), nor are they properly

spirits (since they have a body). More than animal
and less than human, hybrids of body and spirit,
they are purely and absolutely 'creatures'. Created
by God among the material elements and as such
subject to death, they are forever excluded from the
economy of redemption and salvation:

> Although they are both spirit and man, yet
> they are neither [one nor the other]. They
> cannot be man, since they are spirit-like in
> their behavior. They cannot be spirits, since
> they eat and drink, have blood and flesh.
> Therefore, they are a creation of their own,
> outside the two, but of the kind of both, a
> mixture of both, like a composite remedy
> of two substances which is sour and sweet,
> and yet does not seem like it, or two colors
> mixed together which become one and yet
> are two. It must be understood further that
> although they are spirit and man, yet they

are neither. Man has a soul, the spirit not.
[. . .] This creature, however, is both, but
has no soul, and yet is not identical with a
spirit. For, the spirit does not die, but this
creature dies. And so it is not like man, it
has not the soul; it is a beast, yet higher
than a beast. It dies like a beast and the ani-
mal body has no soul either, only man. This
is why it is a beast. But they talk, laugh like
man. [. . .] Christ died and was born for
those who have a soul, that is who are from
Adam, and not for those who are not from
Adam, for they are men but have no soul.[31]

Paracelsus dwells with a sort of loving compassion
on the destiny of those creatures in every way similar
to man but innocently condemned to a purely animal
life:

And so they are man and people, die with
the beasts, walk with the spirits, eat and

drink with man. That is: like the beasts they die, so that nothing is left. [. . .] Their flesh rots like other flesh. [. . .] Their customs and behavior are human, as it is their way of talking, with all virtues, better or coarser, more subtle and rougher. [. . .] In food they are like men, eat and enjoy the product of their labor, spin and weave their own cloth-ing. They know how to make use of things, have wisdom to govern, justice to preserve and protect. For although they are beasts, they have all reason of man, except the soul. Therefore, they have not the judg-ment to serve God, to walk on his path, for they have not the soul.[32]

As non-human men, the elemental spirits described by Paracelsus constitute the ideal archetype of every separation of man from himself (here, too, the analogy with the Jewish people is striking).

Nevertheless, nymphs, as opposed to other non-Adamic creatures, can receive a soul if they enter into sexual union with a man and generate a child with him. Here, Paracelsus is connecting with another, more ancient, tradition that indissolubly tied the nymphs to amorous passion and the reign of Venus (this tradition lies at the origin of both the psychiatric term 'nymphomania' and, perhaps, also of the anatomical term *nymphae*, the small lips of the vulva.) According to Paracelsus, many 'documents' attest that the nymphs 'have not only been truly seen by man, but have had sexual intercourse with him (*copulatae coiverint*) and have borne him children'.[33] If this happens, both the nymph and her offspring receive a soul and thus become truly human:

> It has been experienced in many ways that they are not eternal, but when they are bound to men, they become eternal, that is,

endowed with a soul like man. [. . .] God has created them so much like man and so resembling him, that nothing could be more alike, and a wonder happened in that they had no soul. But when they enter into a union with man, then the union gives the soul. It is the same as with the union that man has with God. [. . .] If there were no such union, of what use would the soul be? Of none. [. . .] From this it follows that they woo man, and that they seek him assiduously and in secret.[34]

Paracelsus places the whole life of nymphs under the sign of Venus and of love. If he calls the society of nymphs 'The Mount of Venus' (*collectio et conversatio, quam Montem Veneris appellitant* [. . .] *congregatio quaedam nympharum in antro* [. . .] How can we not recognize here a topos par excellence of love poetry?), it is because, in truth, Venus herself is

nothing but a nymph and an undine—even if she is the highest in rank and was once, before she died, their queen (*iam vero Venus Nympha est et undena, caeteris dignior et superior, quae longo quidem tempore regnavit sed tandem vita functa est.* Here Paracelsus grapples in his own fashion with the problem of the afterlife of pagan gods).

Condemned in this way to an incessant amorous search of man, nymphs lead a parallel existence on earth. Created not in the image of God but of man, they constitute his shadow or *imago* and, as such, they perpetually accompany and desire that of which they are the image and by which they are at times themselves desired. And it is only in the encounter with man that the inanimate images acquire a soul, become truly alive:

Just as one says: man is the image of God,
that is, he has been made after his image—
in the same way one can also say: these

people are the image of man and made after his image. Now, man is not God although he is made like him, but only as an image. The same here: they are not men because they are made after his image, but remain the same creatures as they have been created, just as man remains the same as God has created him.[35]

The history of the ambiguous relation between man and nymph is the history of the difficult relation between man and his images.

9

The invention of the nymph as the pre-eminent love
object is the work of Giovanni Boccaccio. However,
this is not a creation *ex nihilo*; rather, he is performing
his habitual gesture, both mimetic and apotropaic,
of transposing a Dantean and Stilnovist trope into
a new realm that we could define as 'literature' in
the modern sense (a term we could not apply with-
out quotation marks to Dante and Cavalcanti). Thus
secularizing essentially theological–philosophical
categories, Boccaccio retroactively constitutes as eso-
teric the experience of the love poets (whose practice
in itself is completely indifferent to the esoteric/exo-
teric opposition). By placing literature against an
enigmatic theological background, he both disrupts

and preserves its legacy. At any rate, the *'ninfa fiorentina'* is undoubtedly the central figure of Boccaccio's love poems and prose, at least from 1341 when he composed the *Comedia delle ninfe fiorentine*, a strange prosimetric work composed of novellas and terza rime whose title does not conceal an allusion to Dante's poem. (In 1900, by giving the title *Ninfa fiorentina* to the notebook collecting his correspondence with Jolles, Warburg discreetly evokes Boccaccio, an author especially dear to Jolles.) And once again in his *Ninfale fiesolano*, in the *Carmen bucolicum*, and in a special sense in *Corbaccio*, to love means loving a nymph.

Dante refers to the love object as nymph in few places but they are decisive—in the third epistle, in the *Eclogues* and, above all, in *Purgatory* where she marks a sort of threshold between Eden and Heaven. Among love poets, the amorous object represents the point at which the image or phantasm communicates with the 'possible intellect'. The love object is there-

fore a limit concept, not only between lover and beloved, between subject and object, but also between the individual living being and the 'single intellect' (or thought or language). Boccaccio makes this theo-logico-philosophical limit concept the locus of the specifically modern problem of the relation between life and poetry. The nymph thus becomes the literary quasi-reification of the *intentio* of mediaeval psychology (for this reason, Boccaccio, pretending to give credit to a well-known rumour, will turn Beatrice into a Florentine maiden). The two decisive if apparently antithetical texts here are the introduction to the fourth day of *The Decameron* and *Corbaccio*.

In the introduction, with reference to the opposition between Muses ('tarry with them always we cannot, nor they with us') and women, Boccaccio clearly takes side with the latter; he also proceeds to smooth out the separation: 'The Muses are ladies, and albeit ladies are not the peers of the Muses, yet they have their outward semblance.'[36] In *Corbaccio*,

however, his choice is overturned and the ferocious criticism of women goes hand in hand with the claim of exclusive concern with the *ninfe Castalidi*. Against the women who affirm that 'all good things are female: stars, planets and the Muses', Boccaccio opens up with brusque realism an incurable fracture between them and the Muses: 'It is quite true they are all females, but they don't piss.'[37] With their usual short-sightedness, some scholars have tried to resolve the contradiction between the two texts by projecting it onto a chronology—that is, onto the author's biography—and thus seeing it as an effect of age. The oscillation is instead internal to the question and corresponds to the essential ambiguity of Boccaccio's nymph. The gap between reality and imagination that the Dantean and Stilnovist theory of love meant to repair is here re-introduced in all of its power. If the *ninfale* is that poetical dimension in which the images (that 'do not piss') should coincide with real women, then the *ninfa fiorentina* is always-

already in the process of dividing herself according to her opposed polarities—at once too alive and too inanimate—while the poet no longer succeeds in granting her a unified existence. The imagination, that in the love poets assured the possibility of a conjunction between the sensible world and thought, here becomes the locus of a sublime or farcical rupture into which literature inserts itself (as will, later on, the Kantian theory of the sublime). Modern literature, in this sense, is born from a scission of the mediaeval *imago*.

It is not surprising, then, that in Paracelsus the nymph is presented as a creature of flesh and bone, who is created in the image of man and who can only acquire a soul by uniting with him. The amorous conjunction with the image, symbol of perfect knowledge, becomes the impossible sexual union with an *imago* transformed into a creature that 'eats and drinks' (how can we not recall here Boccaccio's crude characterization of the Muse nymphs?).

10

The imagination is a discovery of mediaeval philosophy. It reaches its critical threshold and its most aporetic formulation in Averroes. The central aporia in Averroism, which elicited obstinate objections from scholastic thought, is in fact situated in the relation between the 'possible intellect', separate and unique, and discrete individuals. According to Averroes, individuals unite (*copulantur*) with the 'single intellect' through the phantasms located in the internal senses, in particular the imaginative faculty and memory. In this way, the imagination is assigned a decisive role—at the highest point of the individual soul, at the limit between the corporeal and incorporeal, the individual and the common,

54

sensation and thought, the imagination is the final waste material that the combustion of individual existence abandons at the threshold of the separate and the eternal. In this formulation, it is imagination, not the intellect, that is the defining principle of the human species.

This definition is nonetheless aporetic, because—as Thomas Aquinas insistently objects in his critique, affirming that, if the Averroist thesis were allowed, then the individual man would not be able to know—it locates imagination in the void that gapes between sensation and thought, between the multiplicity of individuals and the uniqueness of the intellect. Hence—as it usually happens when we try to grasp a threshold or a passage—the vertiginous multiplication of mediaeval psychological distinctions: the sensitive power, the imaginative faculty, the faculty of memory, the material or acquired intellect (*intellectus adeptus*) and so on. Imagination delineates a space in which we are not yet thinking, in

which thought becomes possible only through an impossibility to think. In this impossibility the love poets place their gloss on Averroist psychology— the *copulatio* of phantasms with the 'possible intellect' is an amorous experience and love is, first and foremost, love of an *imago*, of an object in some sense unreal, exposed, as such, to the dangers of anguished doubt (called *dottanza* by the Stilnovists) and of failure [*mancamento*]. Images, which are the ultimate constituents of the human and the only avenues to its possible rescue, are also the locus of the incessant failure of the human to itself [*mancare a se stesso*].

Warburg's project of collecting in the *Atlas* the images (the *Pathosformeln*) of Western humanity must be set against this background. Warburg's nymphs atone for this ambiguous legacy of the image but move it onto a different historical and collective ground. In the *Monarchia*, Dante had already interpreted the Averroist legacy, in the

sense that if man is defined not by thought but by a possibility to think, then this possibility cannot be actuated by a single man but only by a *multitudo* in space and time—that is to say, on the grounds of collectivity and history. To work on images means for Warburg to work at the crossroads, not only between the corporeal and incorporeal but also, and above all, between the individual and the collective. The nymph is the image of the image, the cipher of the *Pathosformeln* which is passed down from generation to generation and to which generations entrust the possibility of finding or losing themselves, of thinking or of not thinking. Therefore images are certainly a historical element; but on the basis of Benjamin's principle, according to which life is given to everything to which history is given (the principle could be reformulated as: life is given to everything to which an image is given), it follows that nymphs are, in some ways, alive. We are used to attributing life only to the biological body. Instead, a purely historical life is

one that is *ninfale*. In order to be truly alive, images, like Paracelsus' elemental spirits, need a subject to unite with them. However, as in the union with the undine, this encounter hides a mortal danger. Indeed, in the course of the historical tradition, images crystallize and turn into spectres which enslave men and from which they always need to be liberated anew. Warburg's interest in astrological images has its roots in the awareness that the observation of the sky is the grace and damnation of man, and that the celestial sphere is the place where men project their passion for images. As it is in the case of the *Vir niger*—the enigmatic astrological decan which Warburg had recognized in the frescoes of Palazzo Schifanoia—in the encounter with the tension-charged dynamogram, the capacity to suspend and reverse the charge and to transform destiny into fortune (*fortuna*) is essential. In this sense, the celestial constellations are the original text in which imagination reads what was never written.

In the letter to Karl Vossler, written a few months before his death, Warburg re-formulates the project of his *Atlas* as a 'theory of the role of human image-memory' (*Theorie der Funktion des menschlichen Bildgedächtnisses*) and relates it to Giordano Bruno's thought: 'You see, here under no circumstances may I let myself be diverted until I succeed in incorporating a figure that has captivated me for forty years and that up to now still has not been properly placed anywhere, as far as I can see, in the history of ideas: Giordano Bruno.'[38]

The Giordano Bruno to whom Warburg is referring can be none other than the Bruno of the magico-mnemotechnical treatises, such as *De umbris idearum*. It is interesting that Frances Yates in *The Art of Memory* (1966) did not realize that the seals Bruno inserted in that text are shaped like natal horoscopes. This resemblance to one of his main objects of research could not have gone unnoticed by Warburg who, in his study on divination in the age of Luther,

reproduces almost identical horoscopes. The lesson
Warburg draws from Bruno is that the art of mas-
tering memory (in his case, more precisely, the
attempt to comprehend the role of the human
Bildgedächtnis through the *Atlas*) has to do with images
expressing human subjection to destiny. The *Atlas* is
the map that must orient man in his struggle against
the schizophrenia of his imagination. The cosmos,
held on the shoulders of the eponymous mythical
hero (Davide Stimilli underlined the importance of
this figure for Warburg), coincides with the *mundus
imaginalis*.[39] The definition of the *Atlas* as 'ghost
stories for adults' finds here its ultimate significance.
The history of humanity is always a history of
phantasms and of images, because it is within the
imagination that the fracture between individual
and impersonal, the multiple and the unique, the
sensible and the intelligible takes place. At the same
time, imagination is the place of the dialectical

recomposition of this fracture. The images are the remnant, the trace of what men who preceded us have wished and desired, feared and repressed. And because it is within the imagination that something like a (hi)story became possible, it is through imagination that, at every new juncture, history has to be decided.

Warburg's historiography is in this respect very close to poetry, in keeping with the indiscernibility of Clio and Melpomene suggested by Jolles in a beautiful essay written in 1925.[40] It is the tradition and the memory of images and, at the same time, humanity's attempt to free itself from them in order to open, beyond the 'interval' between mythico-religious practice and the pure sign, the space for an imagination with no more images. In this sense, the title *Mnemosyne* names the image-less—the farewell, and the refuge, of all images.

Notes

1 Bill Viola, *The Passions* (John Walsh ed.) (Los Angeles: The J. Paul Getty Museum, 2003), pp. 199, 210.

2 Domenico da Piacenza, *Fifteenth-century Dance and Music: Twelve Transcribed Italian Treatises and Collections in the Tradition of Domenico da Piacenza*, VOL. 1 (A. William Smith trans.) (Stuyvesant, NY: Pendragon Press, 1995), p. 11.

3 Ibid., p. 13 (translation modified). In Smith's translation, the list of technical terms—*mesura, memoria, maniera cum mesura de terreno e aire*—is left untranslated.

4 Aristotle, 'On Memory and Recollection' in *Aristotle's Psychology: A Treatise on the Principle of Life* (*De Anima and parva naturalia*) (William Alexander Hammond trans.) (New York: Macmillan, 1902), pp. 195–212; here, p. 211.

5 Albert B. Lord, *The Singer of Tales*, 2nd edn (Stephen Mitchell and Gregory Nagy eds) (Cambridge, MA: Harvard University Press, 2000), p. 13.

6 Aby Warburg and E. H. Gombrich, *An Intellectual Biography* (London: The Warburg Institute, 1970), p. 108.

7 The full title is *The Story of the Vivian Girls, in What is Known as the Realms of the Unreal, of the Glandeco-Angelinnian War Storm, Caused by the Child Slave Rebellion.* Although the novel has not been published, it has been the subject of many exhibitions round the world in recent decades.

8 Walter Benjamin, *Arcades Project* (Howard Eiland and Kevin McLaughlin trans) (Cambridge, MA: Harvard University Press, 1999), p. 463.

9 Walter Benjamin, *Gesammelte Schriften,* VOL. 1 (Rolf Tiedemann and Herman Schweppenhäuser eds) (Frankfurt: Surhkamp, 1974–89), p. 1229. The lines by Henri Focillon are from *The Life of Forms in Art* (George Kubler trans.) (New York: Zone Books, 1989), p. 55, and may also be located in the notes made by Benjamin while preparing his 'On the Concept of History'.

10 Walter Benjamin, 'On the Concept of History', in *Selected Writings*, VOL. 4, 1938–40 (Cambridge, MA: Harvard University Press, 2006), pp. 389–400; here, p. 396.

11 Theodor W. Adorno and Walter Benjamin, *The Complete Correspondence: 1928–1940* (Henri Lonitz ed. and Nicholas Walter trans.) (Cambridge, MA: Harvard University Press, 1999), p. 114–15.

12 Benjamin, *Arcades Project*, p. 466.

13 Adorno and Benjamin, *The Complete Correspondence*, p. 108.

14 See Enzo Melandri, *La linea e il circolo*: *Studio logico-filosofico sull'analogia* (Macerata: Quodlibet, 2004), p. 798.

15 Friedrich Theodor von Fischer, 'Das Symbol' in *Altes und Neues* (Stuttgart: A. Bonz and Company, 1889), pp. 290–342; here, p. 306.

16 Ibid., p. 307.

17 Cited by Georges Didi-Huberman in *L'image survivante*: *histoire de l'art et temps des fantômes selon Aby Warburg* (Paris: Éditions de Minuit, 2002), p. 183.

18 This is the title of a 1918 essay by Warburg.

19 The allusion is to Salomon Friedländer's book, *Schöpferische Indifferenz* (1918). See Walter Benjamin, 'The Mendelssohns' *Der Mensch in der Handschrift* in *Collected Writings*, VOL. 2 (Rodney Livingstone trans.) (Cambridge, MA: Harvard University Press, 2005), p.133.

20 Gianni Carchia, 'Aby Warburg. Simbolo e tragedia', *Aut-Aut* 199–200 (1984): 100–01.

21 Warburg, 'Allgemeine Ideen', p. 37. Cited by Didi-Huberman in *L'image survivante*, p. 339.

22 See Didi-Huberman, *L'image survivante*, p. 182.

23 From unpublished manuscripts in the Warburg Institute Archive.

24 Warburg and Gombrich, *An Intellectual Biography*, p. 255 (translation modified).

25 Ibid., p. 108.

26 Ibid., p. 124.

27 Paracelsus, 'A Book on Nymphs, Sylphs, Pygmies, and Salamanders, and on the Other Spirits' in *Four Treatises of Theophrastus von Hohenheim called Paracelsus* (Henry E. Sigerist trans.) (Baltimore, MD: The Johns Hopkins University Press, 1941), pp. 223–53.

28 Warburg and Gombrich, *An Intellectual Biography*, p. 110.

29 Paracelsus, 'A Book on Nymphs', p. 229.

30 Ibid., p. 227.

31 Ibid., pp. 228–9.

32 Ibid.

33 Ibid., p. 236 (translation modified).

34 Ibid., pp. 238–9.

35 Ibid., p. 229.

36 Giovanni Boccaccio, *The Decameron*, VOL. 1 (J. M. Rigg trans.) (London: A. H. Bullen, 1903), p. 262.

37 Giovanni Boccaccio, *The Corbaccio* (Anthony K. Cassell trans.) (Urbana, IL: University of Illinois Press, 1975), p. 32 (translation modified).

38 Aby Warburg's letter to Karl Vossler, 12 October 1929. From the Warburg Institute Archive.

39 Davide Stimilli, 'L'impresa di Warburg', *Aut Aut* 321–2 (2004): 97–116.

40 See André Jolles, 'Clio en Melpomene', *De Gids* 89(3) (1925): 400–03.